PEOPLE KNITTING

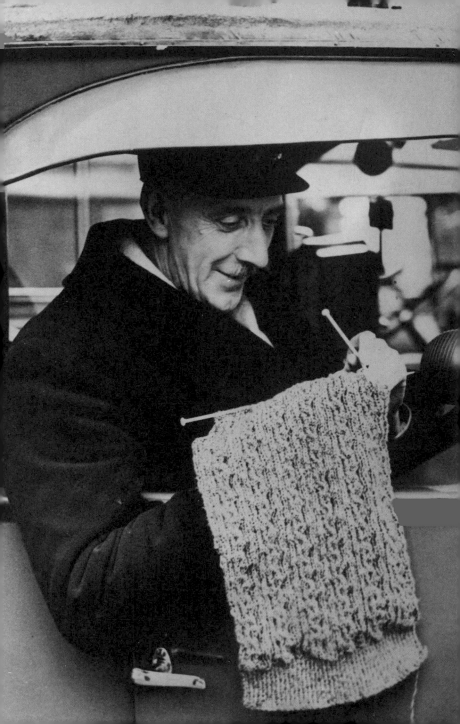

PEOPLE KNITTING

A Century of Photographs

Barbara Levine

PRINCETON ARCHITECTURAL PRESS

NEW YORK

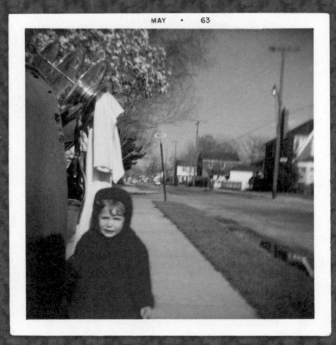
MAY • 63

T he one hundred photographs in this book, dating from
the 1860s to the 1960s, are of people knitting. They
come primarily from my personal collection of vintage
vernacular photographs, which I started over twenty-five years
ago when a passion for old photographs took hold of me.

Without fail, whenever I find a snapshot of someone knitting
it makes me think of my mother. One of my earliest memories
of my mother was watching her knit and listening to the sound of
knitting needles constantly clicking. The combination of her intense
focus on what she was doing and the rhythmic sound of her
needles *click, click, click*ing created an air in the room that signaled
something important was happening. Whenever my mother
was in her knitting trance (as I called it), I knew not to interrupt
her, and often I would complain: "All you do is knit!"

I do not have a single snapshot of my mother knitting, but I
do have photos of me as a child wearing many of her creations.
Here I am at age three standing on our Detroit sidewalk, shrouded
in a blazing red mohair coat and hat that she made for me. It was
hard to smile for the camera while clad head to toe in scratchy mohair
on an unusually warm May day!

I have never been a knitter, but I guess I could call myself
a knitter-watcher. It is mesmerizing, even awe-inspiring, to
see a ball of yarn transformed through some magical choreography
of fingers and needles into items functional or fanciful. Yet, if

you're a non-knitter, observing a knitter can also be baffling. To watch people knit is to be invited into their private world of contemplation and innermost creative expression, but at the same time, they are preoccupied—mapping out a pattern, counting a line, envisioning some future garment that you can't imagine and may never see.

I have a special fascination for the intersection of knitting and photography. For while knitting has been around for centuries, it is only in the last 150 years that we have been able to actually photograph someone—a mother, daughter, sister, brother, father, son, or friend—in the meditative act of knitting.

These images of knitters provide a glimpse into a daily pastime that was an unlikely subject for photography. We get to peek behind the yarn curtain, to speculate: What kinds of people liked to knit? What are they knitting? And why did they want to be photographed with their knitting?

In the mid-1800s knitting wasn't just a hobby, as it often is today, but an essential household craft. When a woman was posed with her knitting in early photographs, it was an expression of her virtue and skill as a homemaker. In Victorian times knitting became fashionable among wealthy women, and many photographic portraits convey knitting as a sign of culture and artistic ability. During times of war, knitting's popularity soared, and in photographs made during World War I and World War II, it is common to find movie stars, Red Cross nurses, soldiers, prisoners, and members of knitting clubs—men, women, girls, and boys of all ages and from all over the world, with their heads bent down, focused on knitting items (especially socks) for the troops. In the 1950s and 1960s, as photography became more ubiquitous, people look more comfortable in front of the camera with their knitting.

At the simplest level, the images in this book of people
knitting are delightful vintage photographs we can enjoy
for their individual charm as portraits, snapshots, or whimsical
artifacts of bygone days. But they reward on another level, too,
for they often contain a hint about what the act of knitting has meant
personally and culturally at different points in history. Whether
as a symbol of virtuosity ("idle hands are the devil's workshop")...
or as a gesture of wartime patriotism... or to document the
sitter's personal idiosyncrasy... these images of knitters open
up worlds of interpretation, while always being, first and foremost,
fun to look at.

BARBARA LEVINE

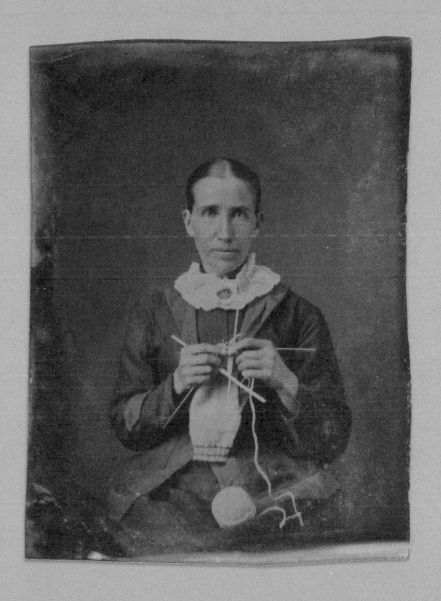

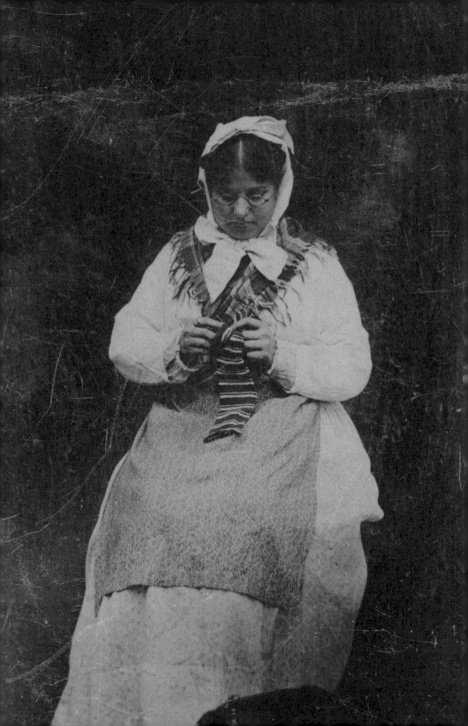

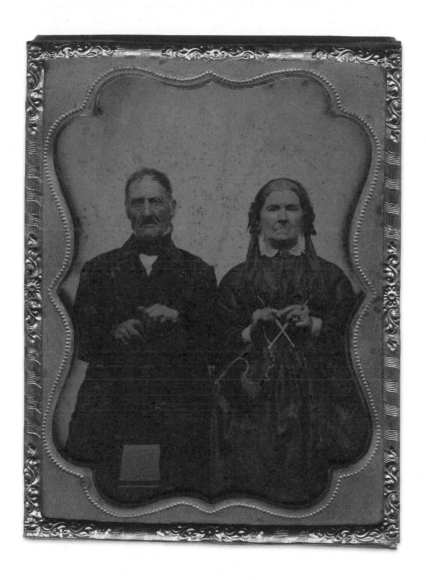

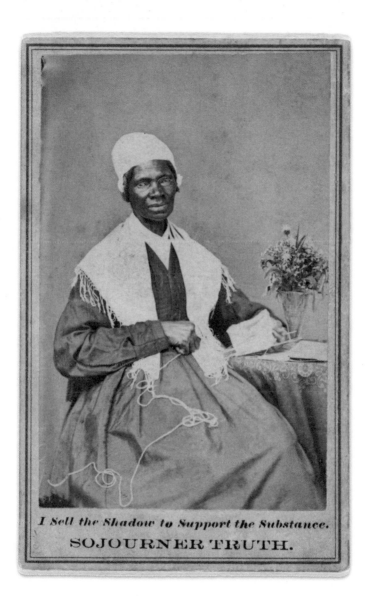

I Sell the Shadow to Support the Substance.

SOJOURNER TRUTH.

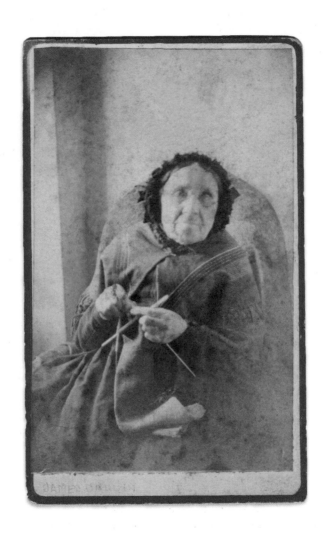

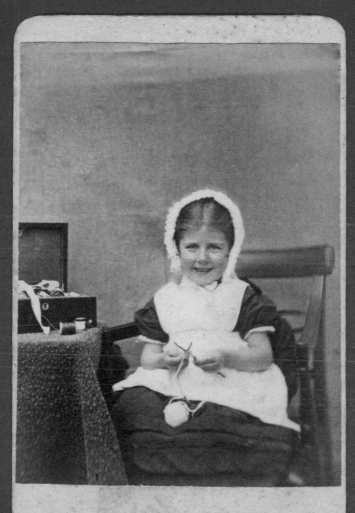

"THE CHEERFUL OLD LADY."

POULTON & SON.

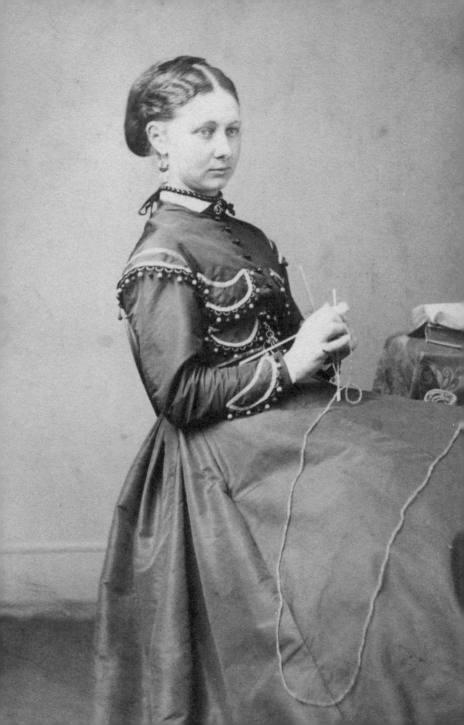

❝ Knitting appears altogether mechanical, and the knitter keeps up her knitting even while she reads or is engaged in lively talk. But if we ask her how this is possible, she will hardly reply that the knitting goes on of itself. She will rather say that she has a feeling of it, that she feels in her hands that she knits and how she must knit, and that therefore the movements of knitting are called forth and regulated by the sensations associated therewithal, even when the attention is called away. ❞

—PROFESSOR WILLIAM JAMES, "LAWS OF HABIT,"
POPULAR SCIENCE MONTHLY, 1887

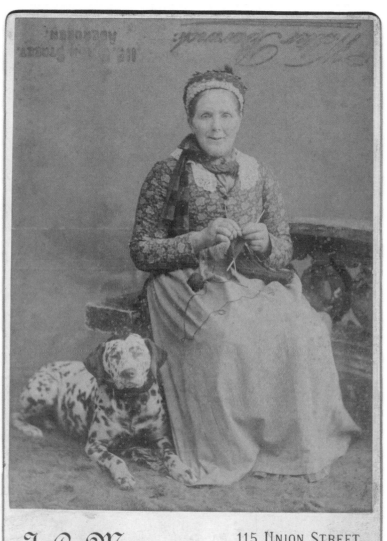

F. C. Munro.

115 Union Street,
Aberdeen.

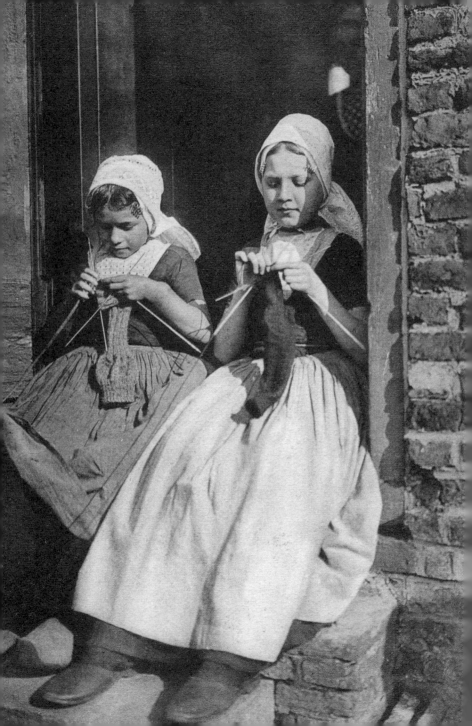

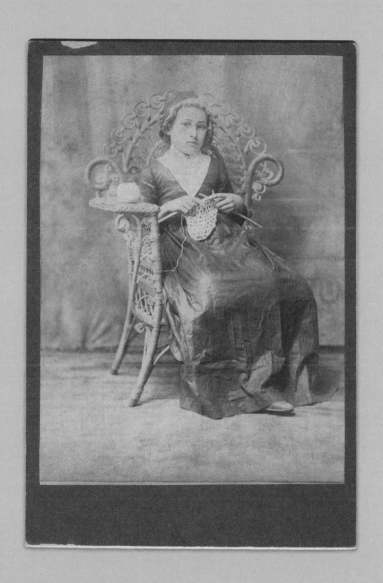

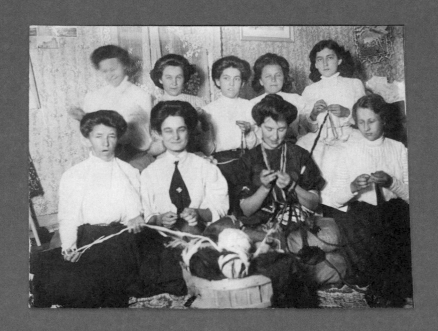

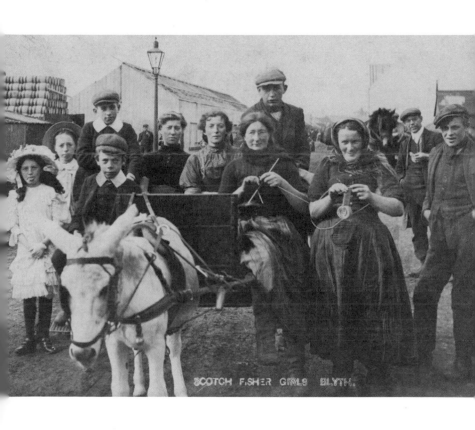

SCOTCH FISHER GIRLS BLYTH.

My Dear Grace,.

I forgot to tell you to be sure and bring your knitting.

Hastily

J. M. B.

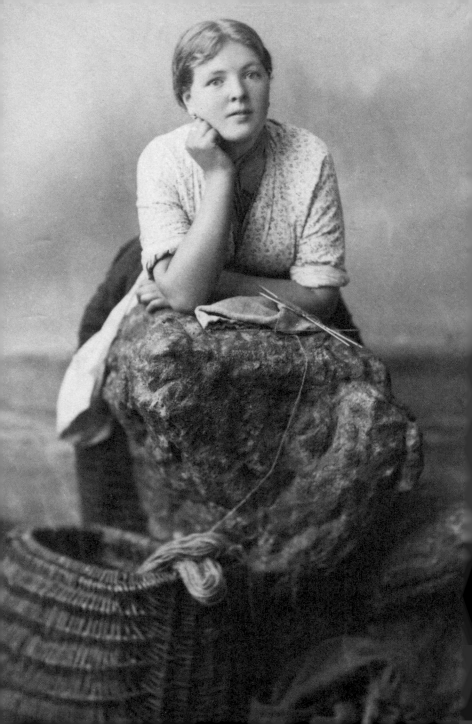

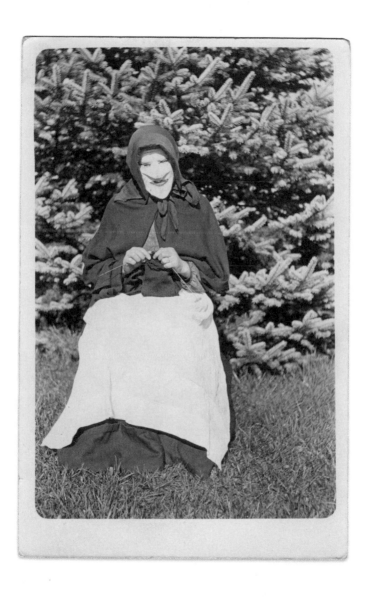

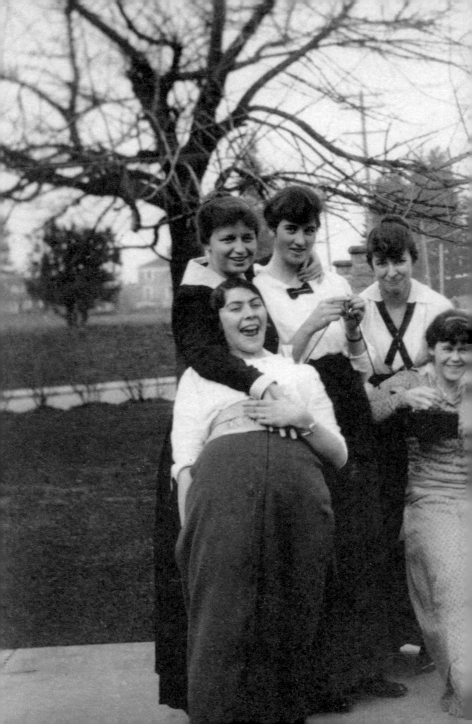

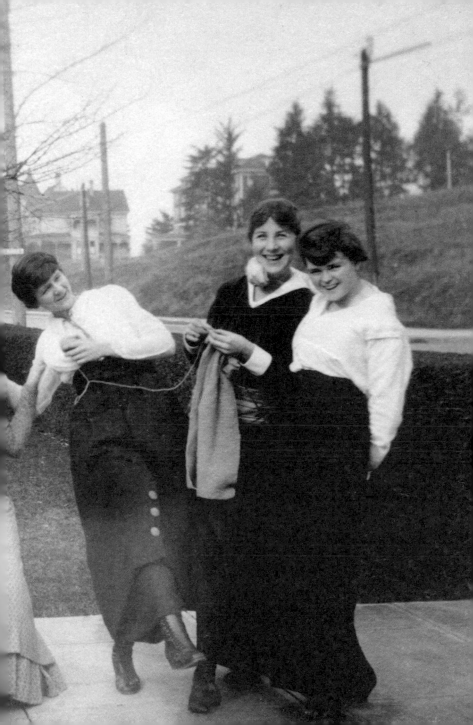

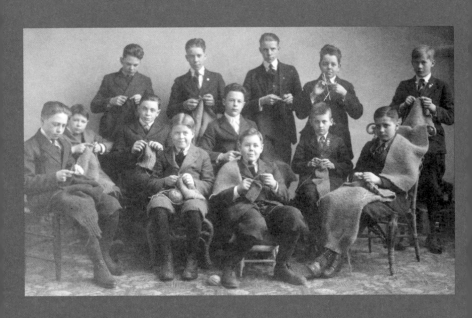

" Knitting's the best thing ever to steady your nerves. The boys in our room that used to sit and fumble their inkwells, or tap their pencils, or tinker with their rulers, or maybe flip bits of art-gum at you when somebody was reciting, are so busy with their knitting that they never fidget or misbehave. **"**

—*ST. NICHOLAS* MAGAZINE ARTICLE ABOUT THE
ROCKY MOUNTAIN KNITTER BOYS, FROM MAPLETON,
COLORADO, MAY 1918

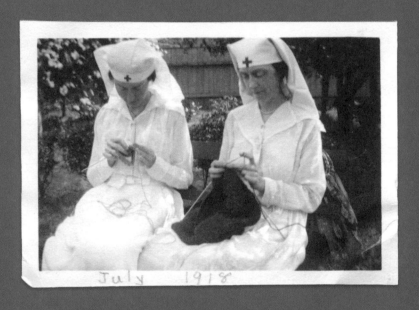

July 1918

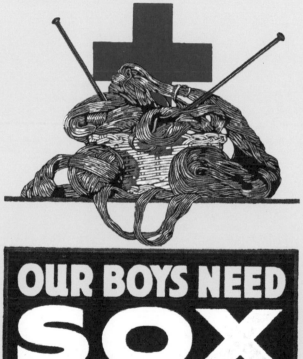

AMERICAN RED CROSS

OUR BOYS NEED
SOX
KNIT YOUR BIT

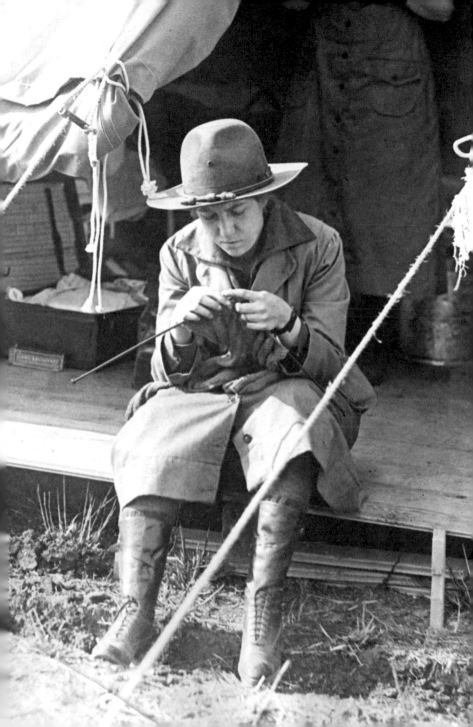

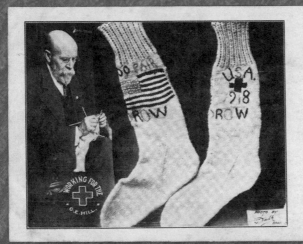

A PAIR
OF SOCKS
FOR
PRESIDENT
WILSON,
KNIT BY
GEO. E. HILL
104
CENTER ST.,
DAYTON, O.

Faithful Red Cross Worker

That others may be influenced to take up the Red Cross work, we are presenting you with this card, showing George E. Hill at work knitting. This is his one hundredth pair of socks and was presented to **President Wilson.** Mr. Hill does his knitting from 3 a. m. to 7 a. m. and also Sundays, completing a pair each Sunday.

SMITH BROS., Photographers,
18 E. Fourth St., Dayton, O.

(OVER)

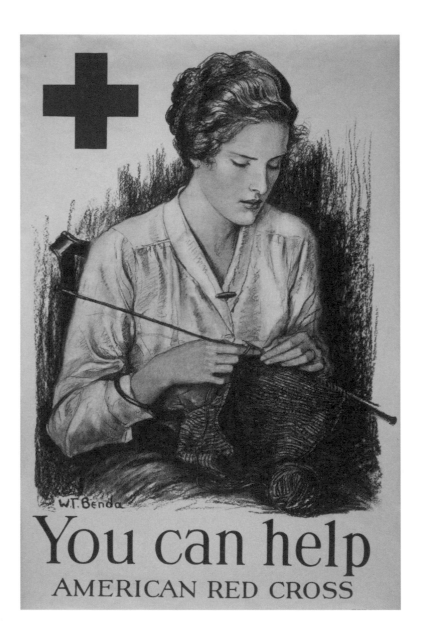

You can help

AMERICAN RED CROSS

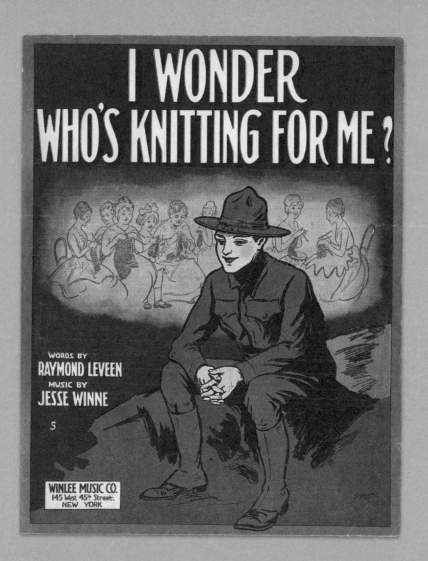

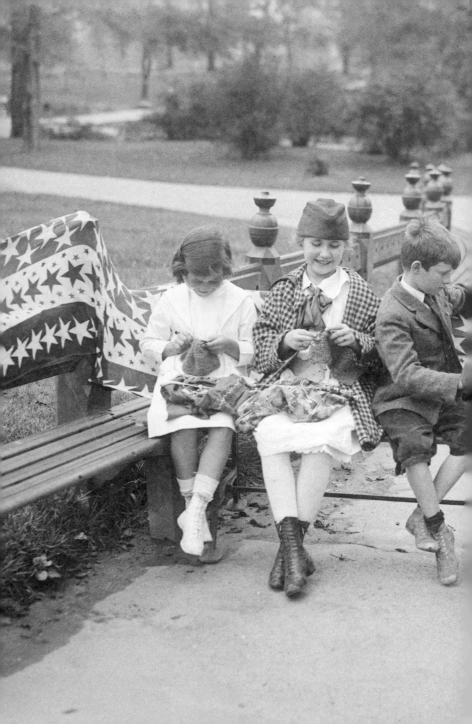

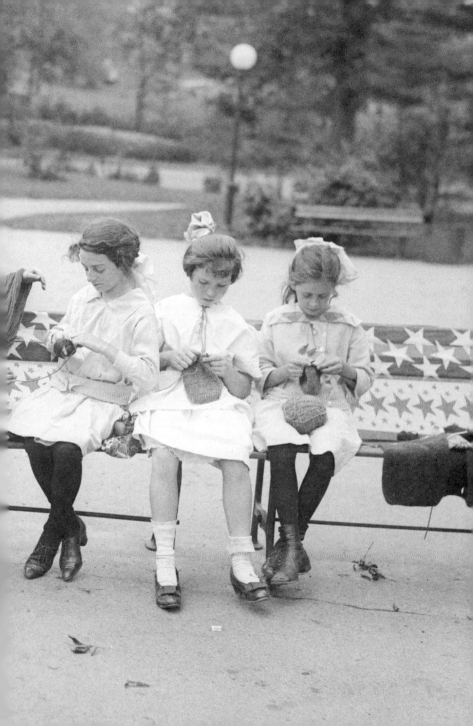

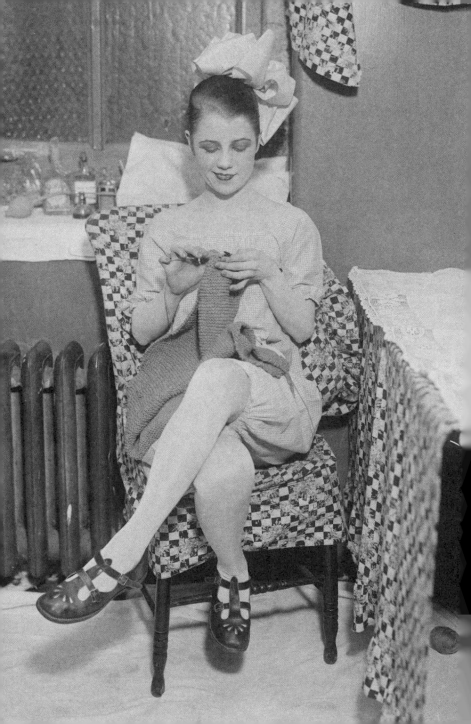

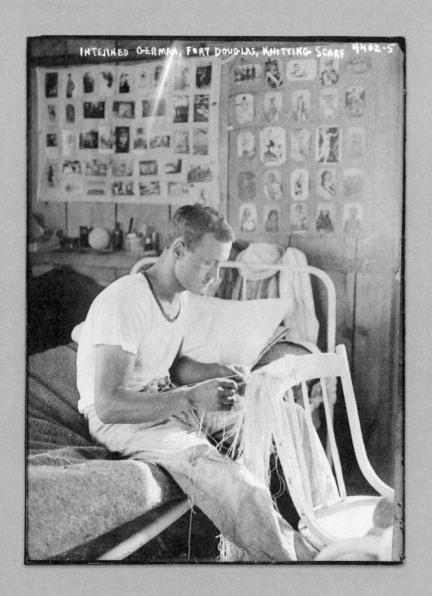

INTERNED GERMAN, FORT DOUGLAS, KNITTING SCARF 4402-5

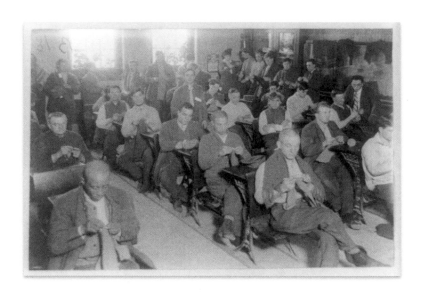

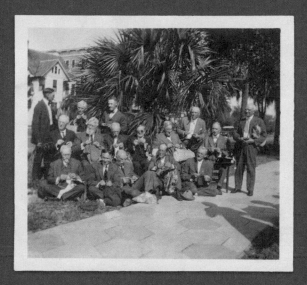

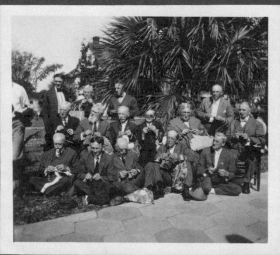

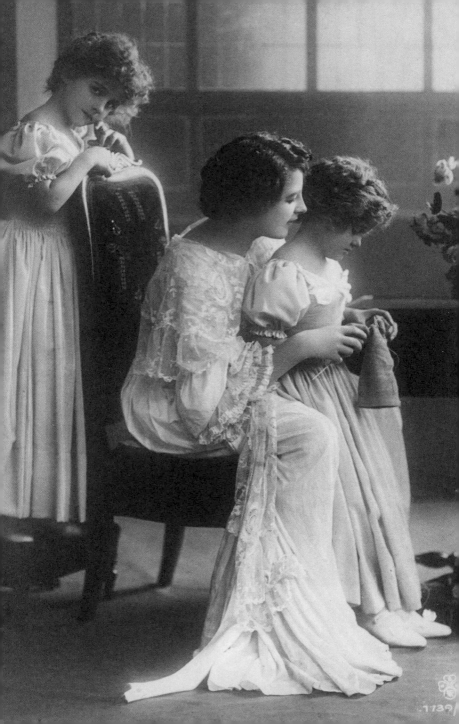

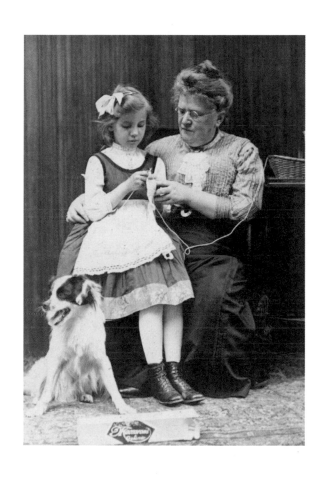

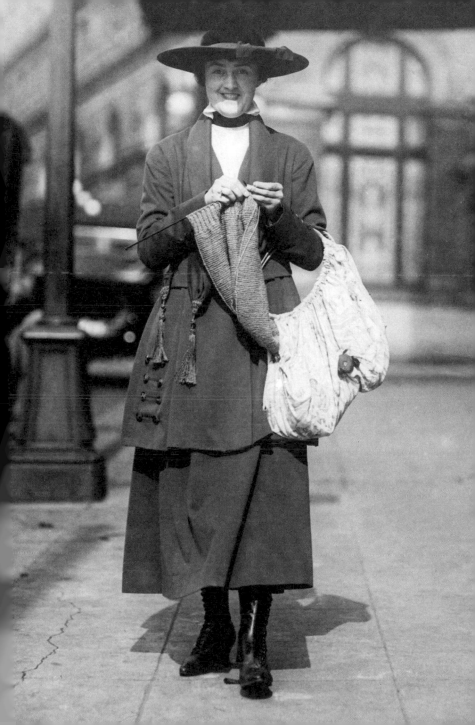

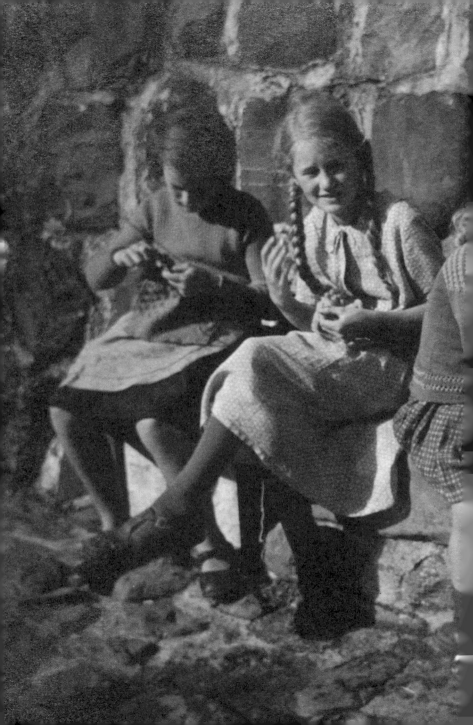

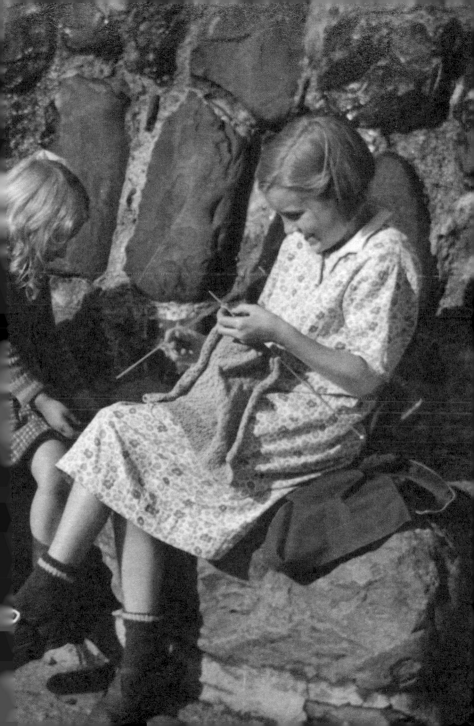

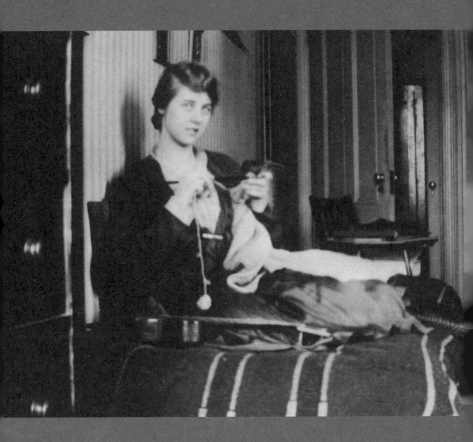

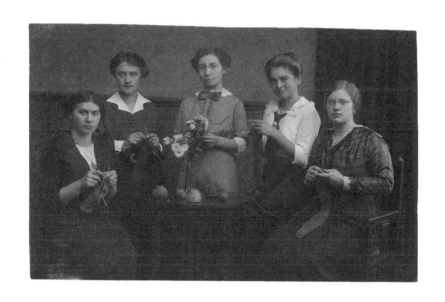

"Knitting During Performances.

The Philharmonic Society fully appreciates the spirit that prompts charitable assistance in the great world's calamity caused by the European war, but many complaints have been received from patrons of the concerts who are annoyed by knitting during performances, and the Directors respectfully request that this practice, which interferes with the artistic enjoyment of the music, be omitted. FELIX F. LEIFELS, Manager "

—NOTICE POSTED IN CONCERT HALL BY THE NEW YORK
PHILHARMONIC SOCIETY, CA. 1915

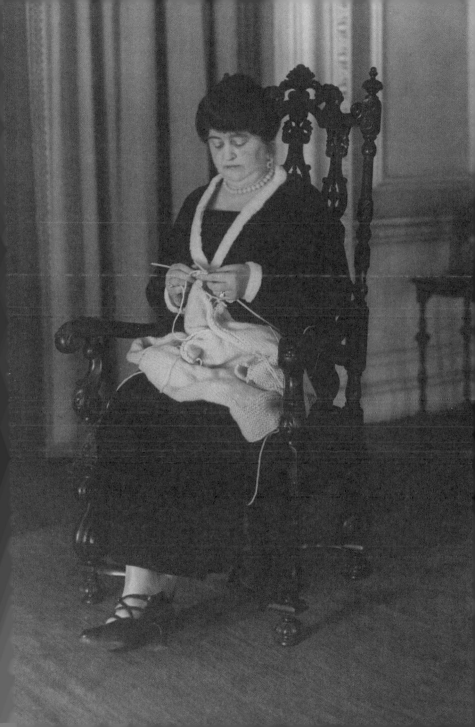

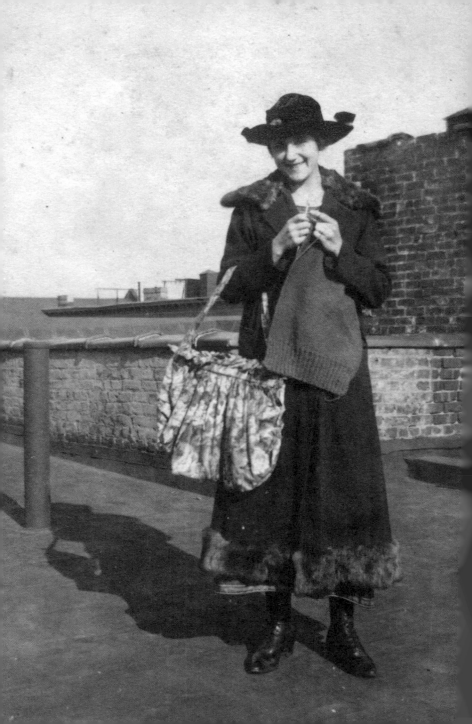

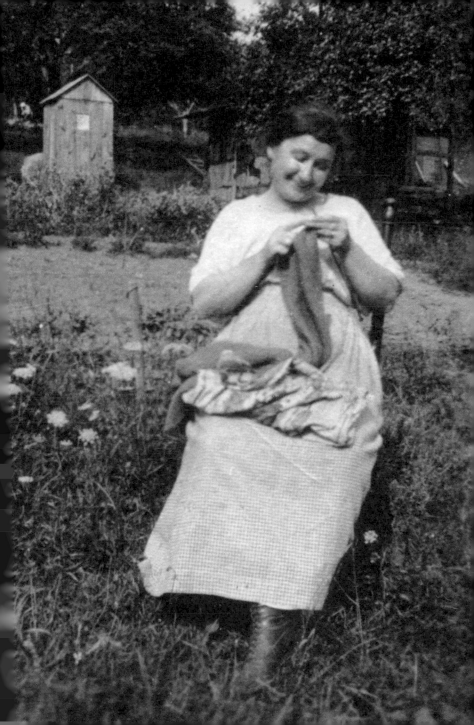

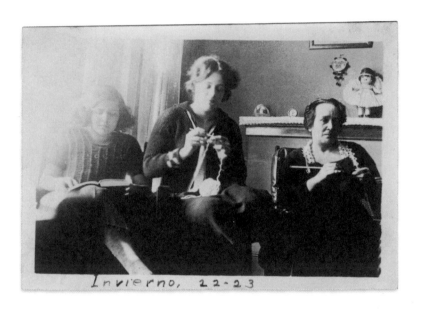

Invierno, 22-23

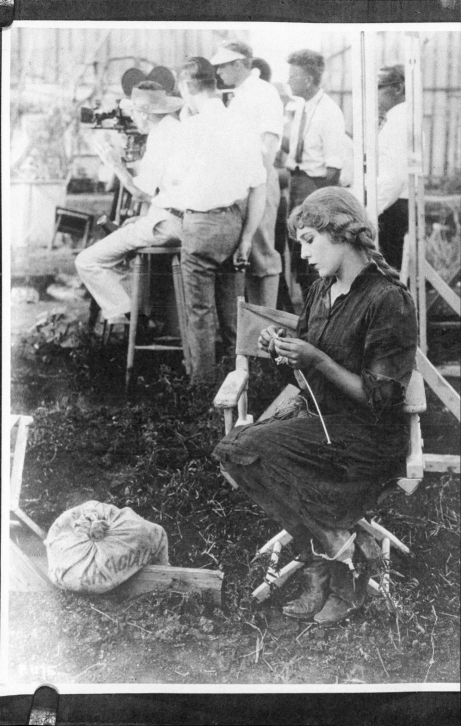

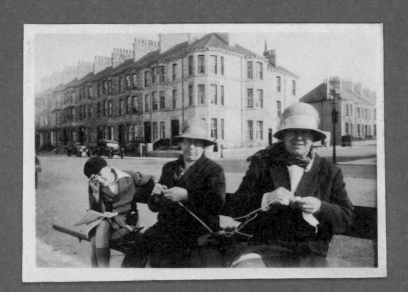

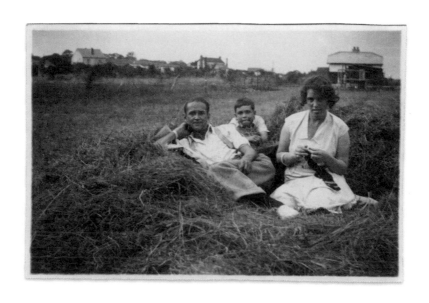

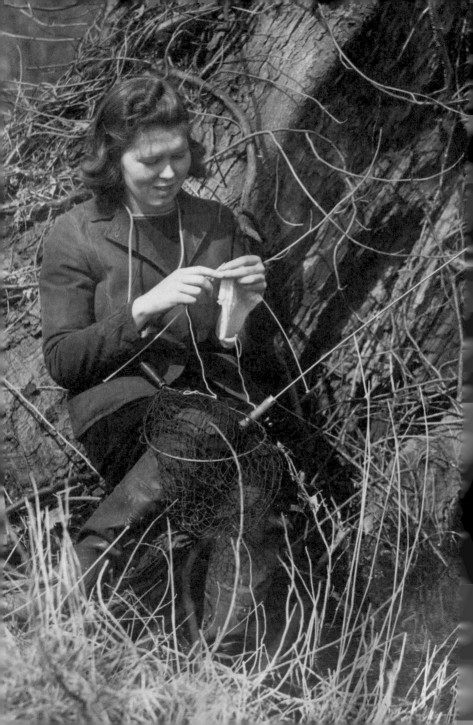

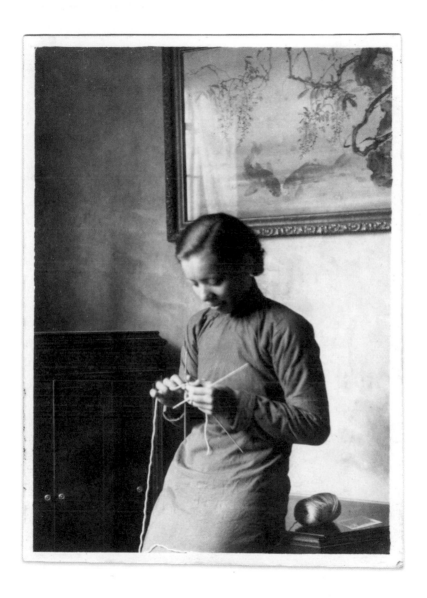

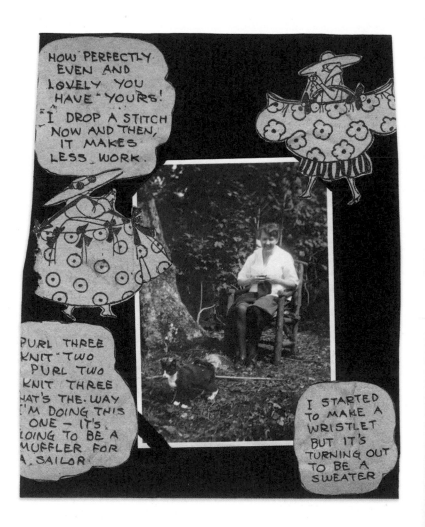

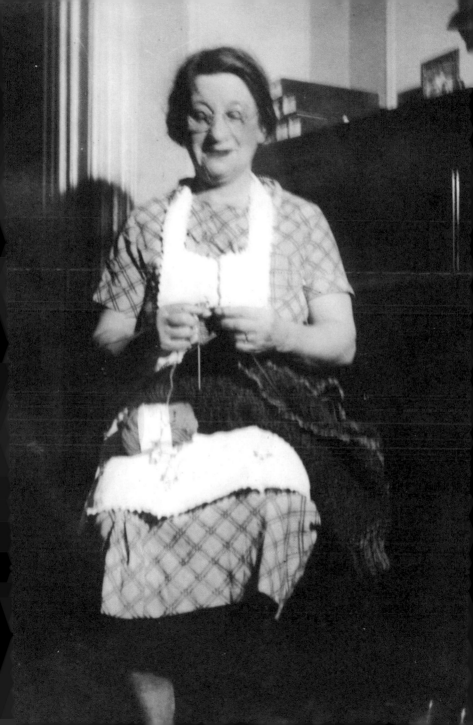

" Properly practiced, knitting soothes the troubled spirit, and it doesn't hurt the untroubled spirit either. "

—ELIZABETH ZIMMERMANN

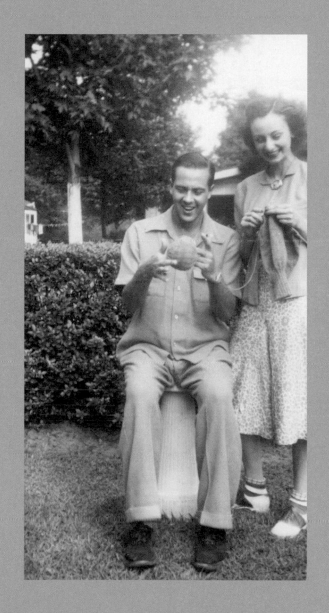

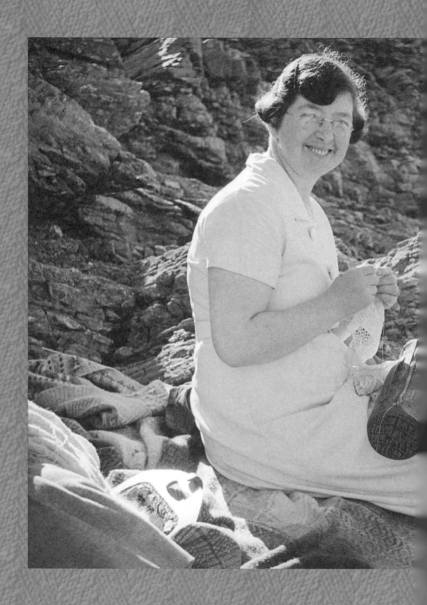

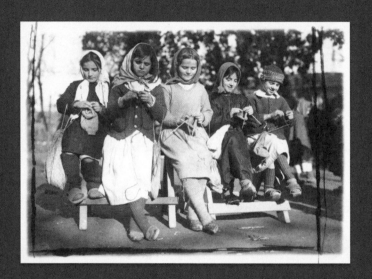

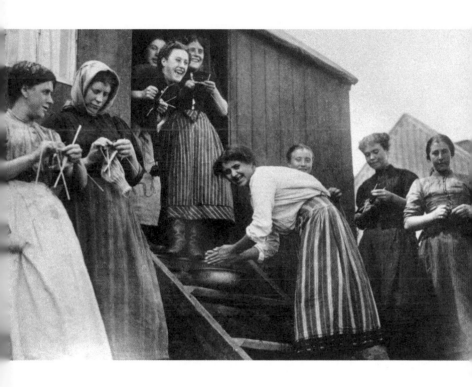

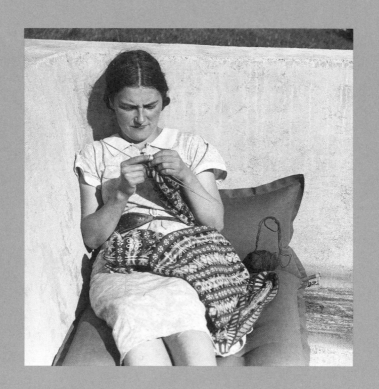

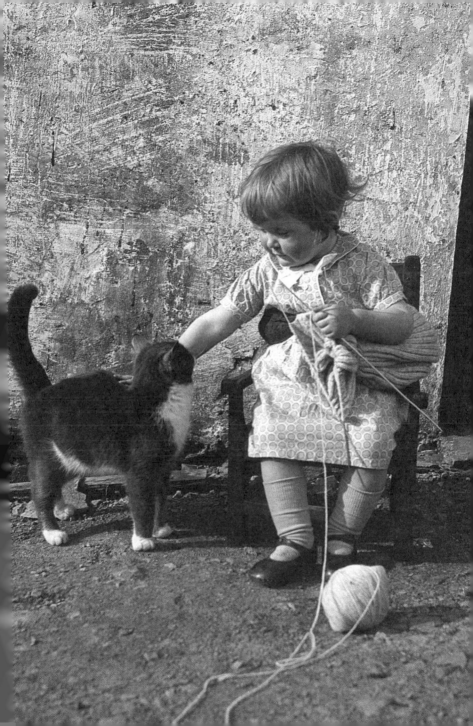

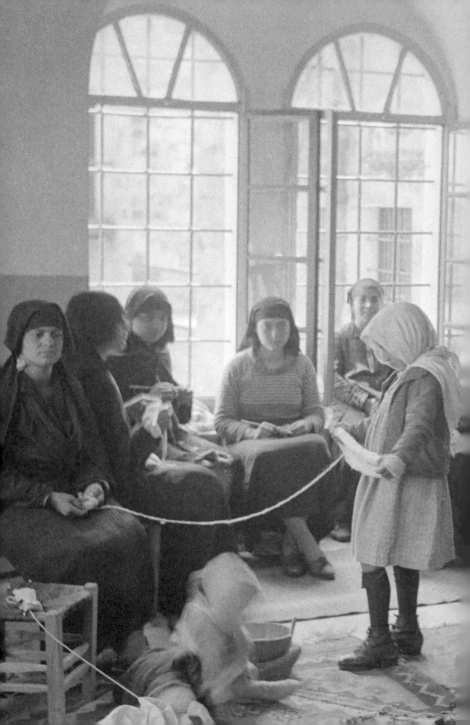

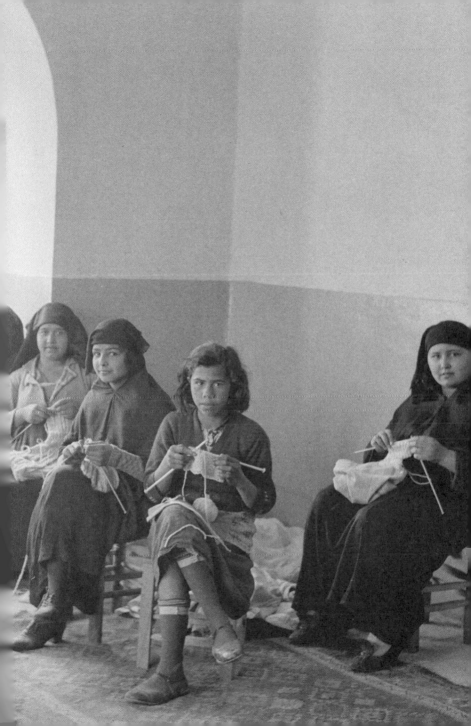

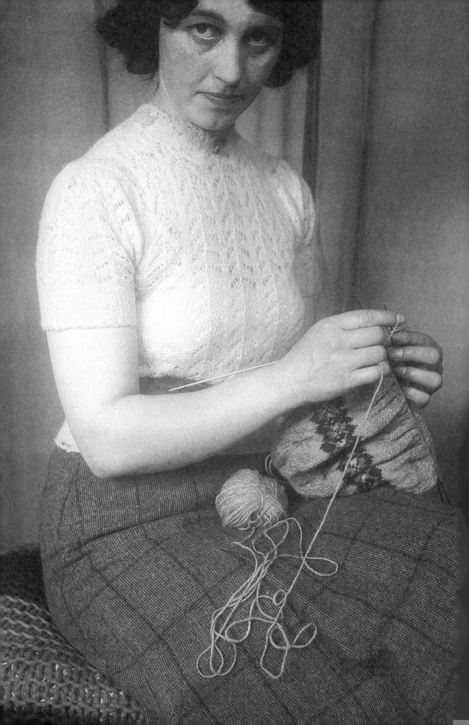

" I found myself a keen and ever-developing sympathy for the dislike some men have for women knitting.... When a man watches a woman knitting he feels shut out. She is absorbed by an occupation he cannot share. She is in a sanctuary where he cannot follow. And her knitting folds her in solidarity with other women. "

—*ATLANTIC MONTHLY,* MAY 1936

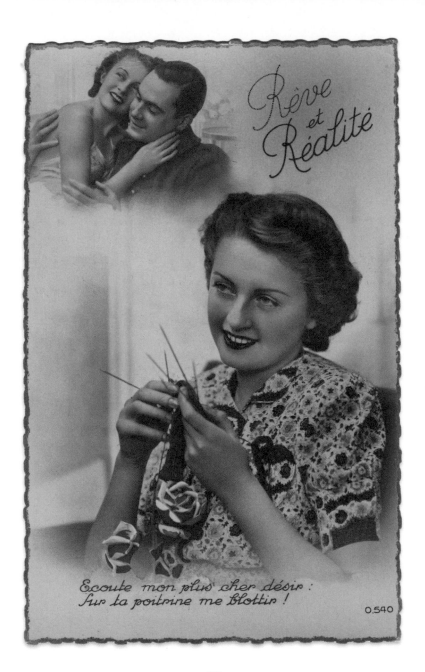

Rêve
et
Réalité

Écoute mon plus cher désir :
Sur ta poitrine me blottir !

O.540

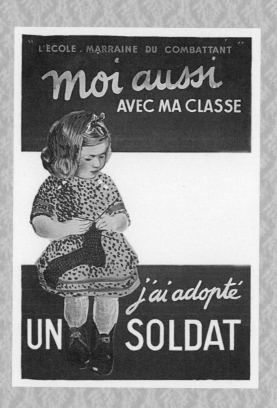

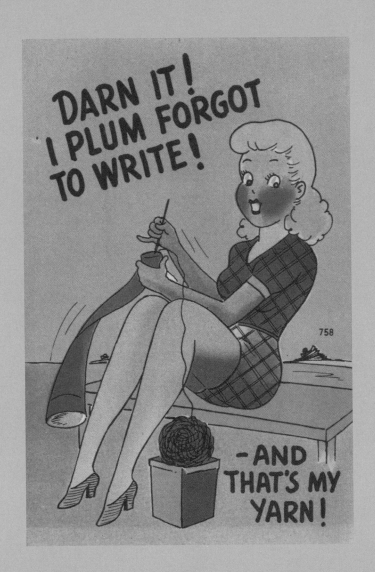

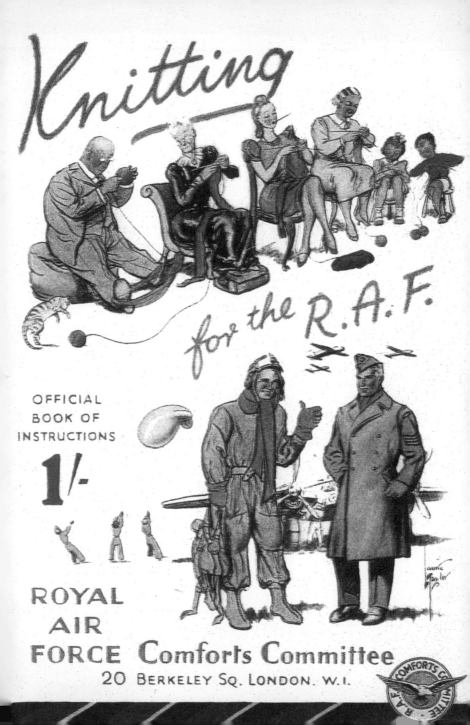

Knitting

for the R.A.F.

OFFICIAL
BOOK OF
INSTRUCTIONS

1/-

ROYAL
AIR
FORCE Comforts Committee
20 BERKELEY SQ. LONDON. W.1.

R.A.F. COMFORTS COMMITTEE

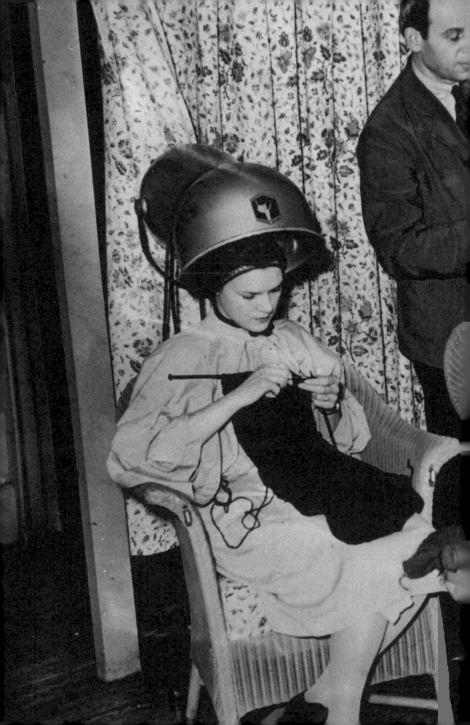

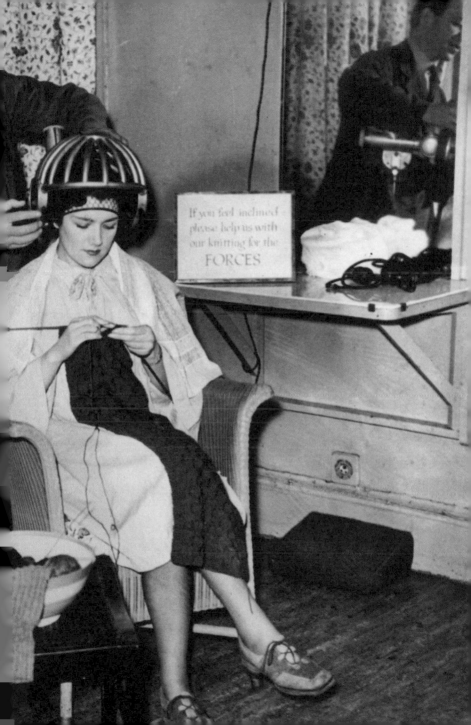

If you feel inclined
please help us with
our knitting for the
FORCES

Cheer Up and Sing With Flossy Frills

Here's the Song She Inspired For the Girl He Left Behind

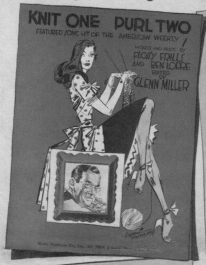

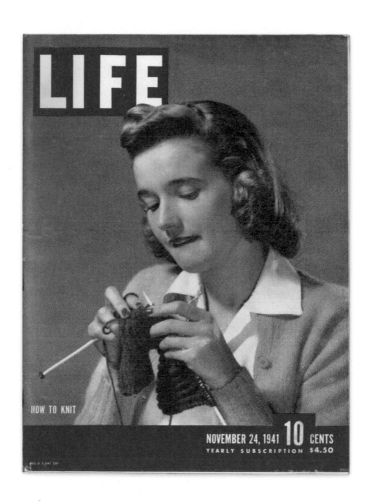

LIFE

HOW TO KNIT

NOVEMBER 24, 1941 **10** CENTS
YEARLY SUBSCRIPTION $4.50

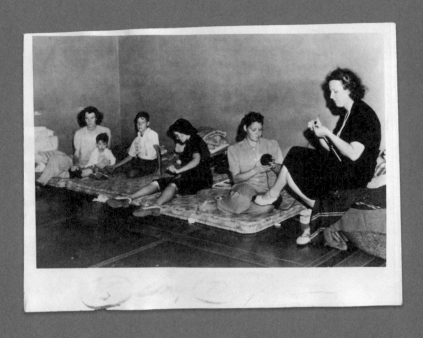

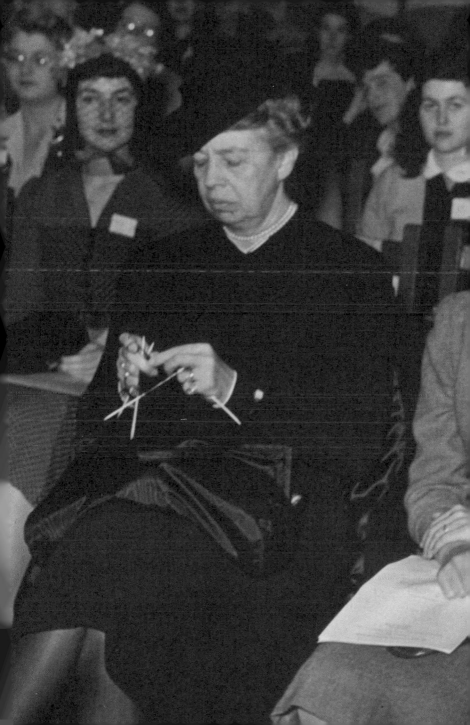

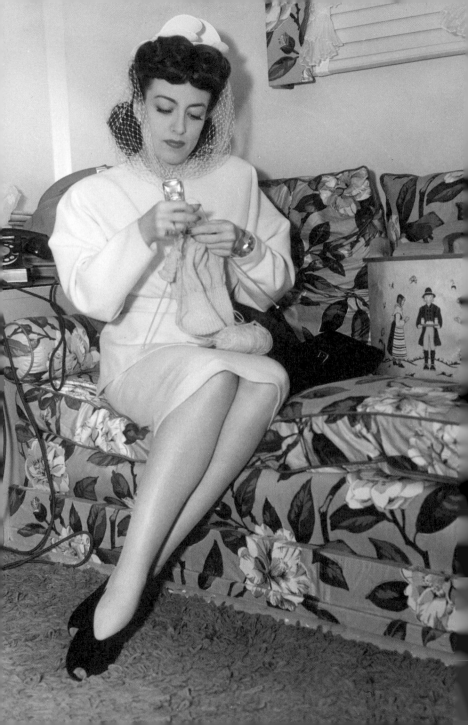

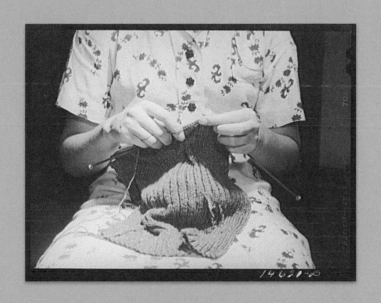

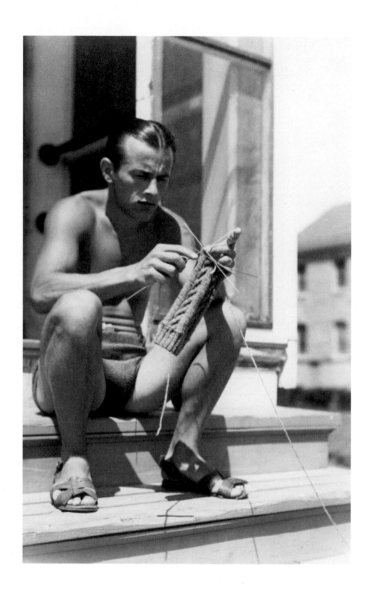

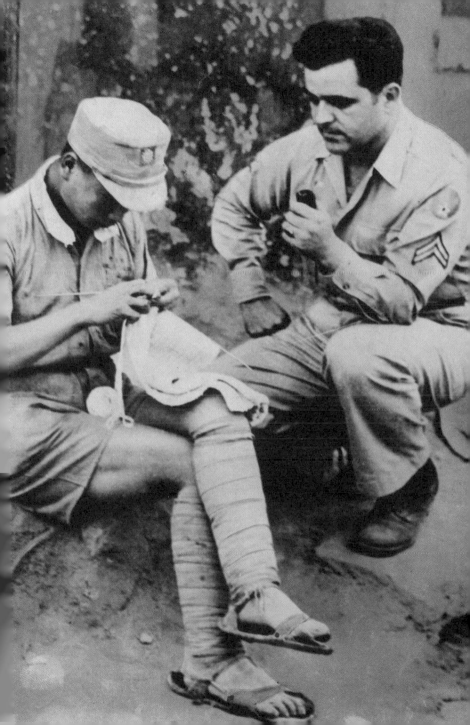

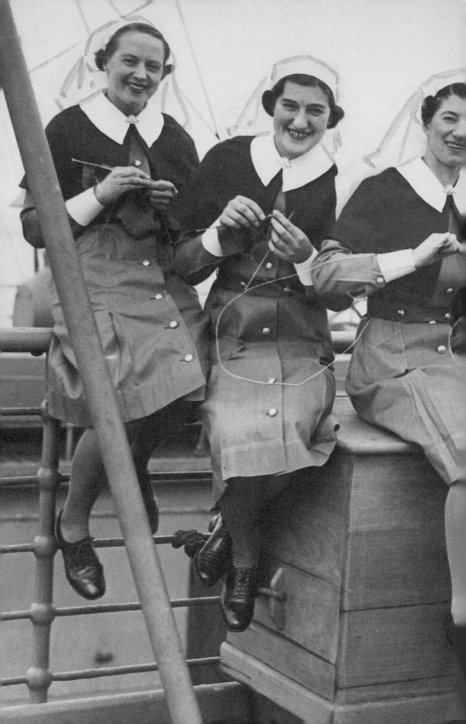

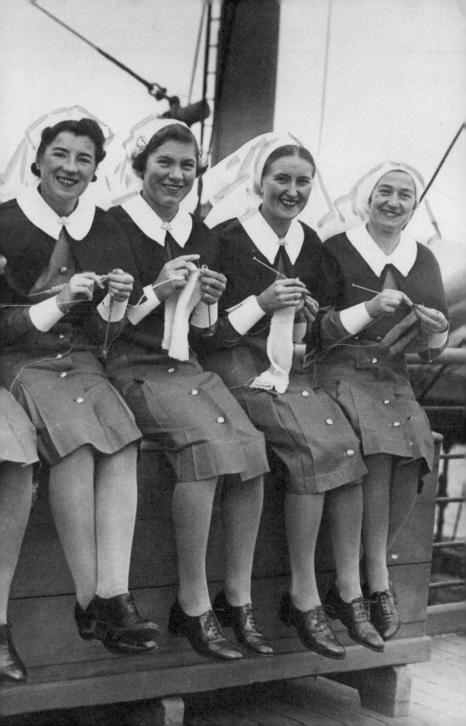

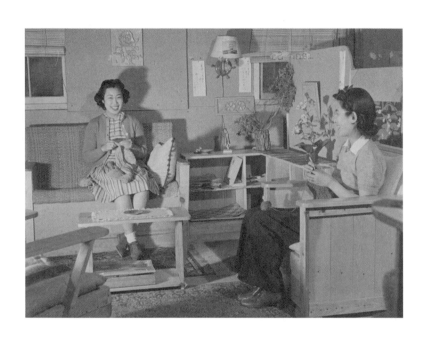

Knitting Socks For Hubby

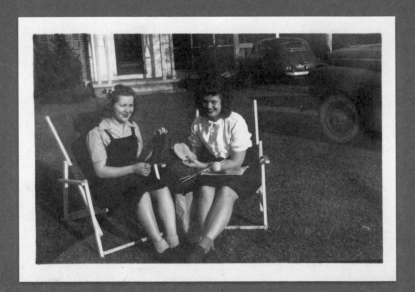

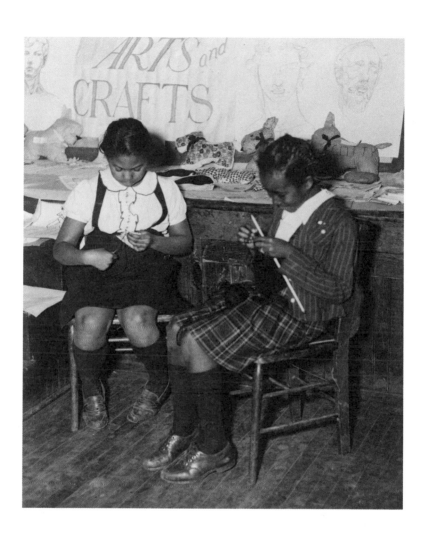

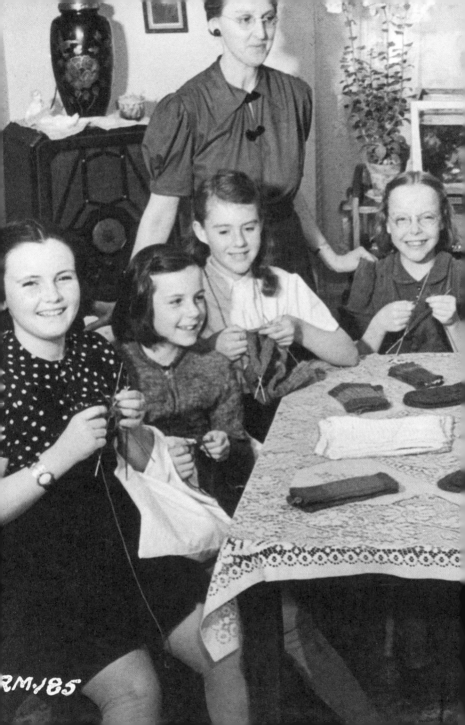
RM.185

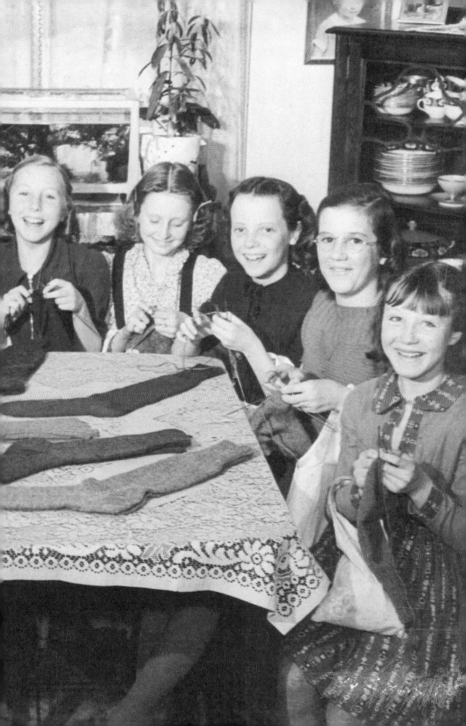

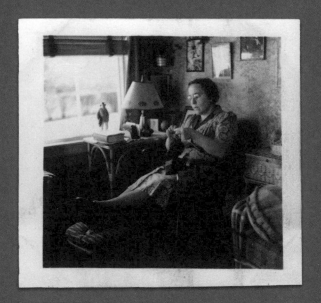

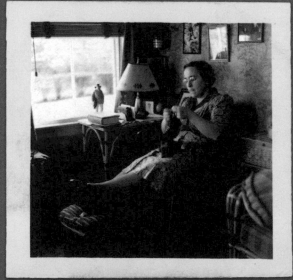

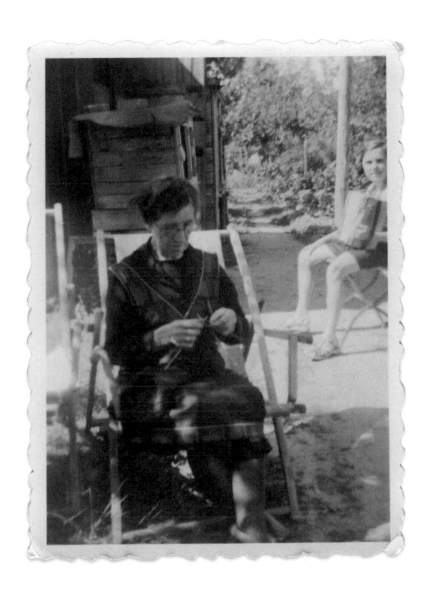

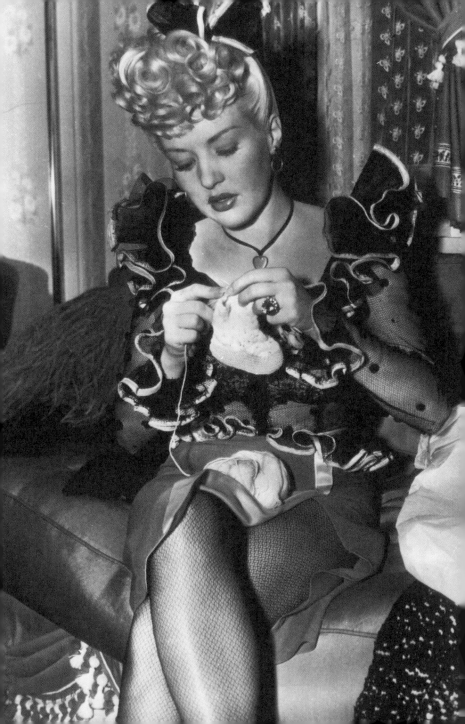

" Do not wave
long or
shiny needles. **"**

—EMILY POST, "ETIQUETTE AND THE WAR,"
NEW YORK TIMES, MAY 17, 1943

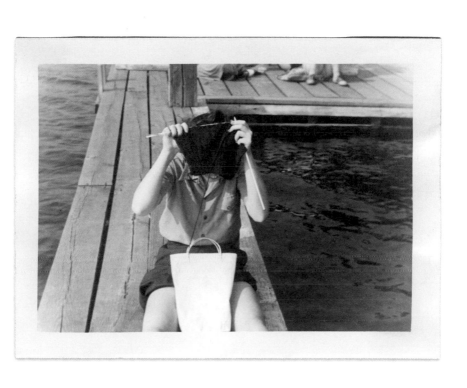

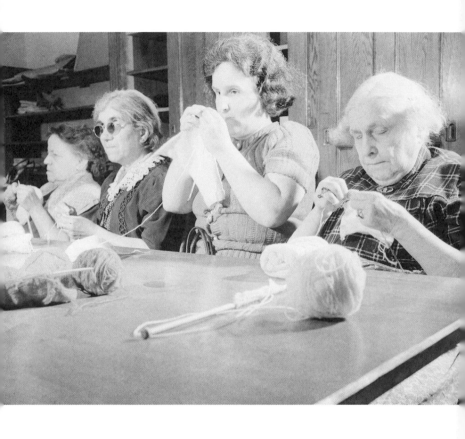

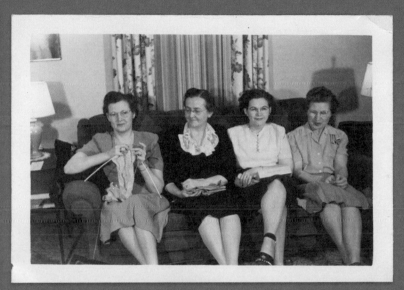

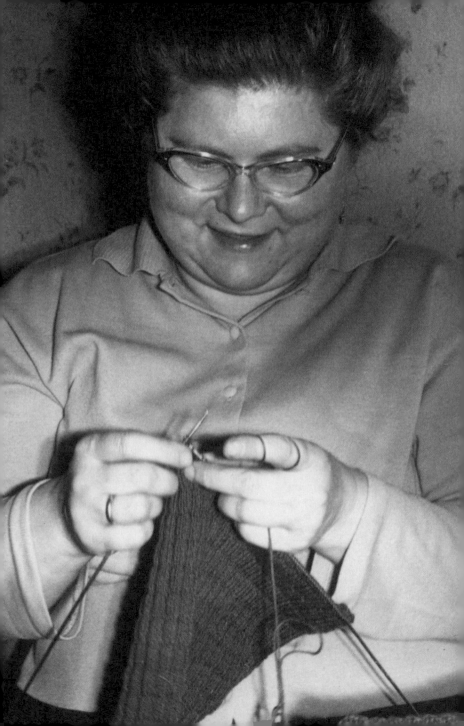

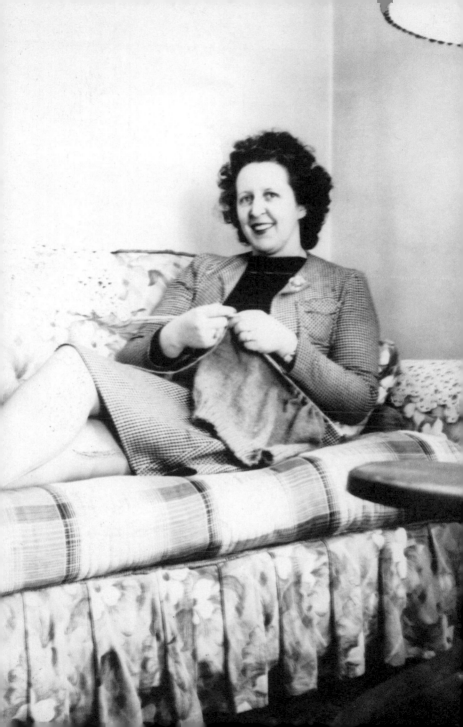

[A journalist observed another man]

" knitting openly and shame-
lessly, as he might have read
a newspaper or smoked
a cigar.... He slipped the first
stitch, knit one, and purled
two as nonchalantly as if
he were knocking billiard
balls about the table or teeing
his ball for a long drive...
and counted his stitches with
a veteran's assurance. **"**

—*ATLANTIC MONTHLY, 1919*

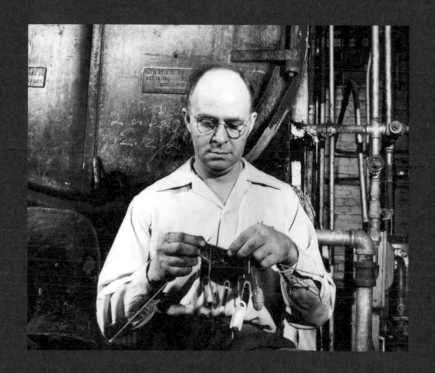

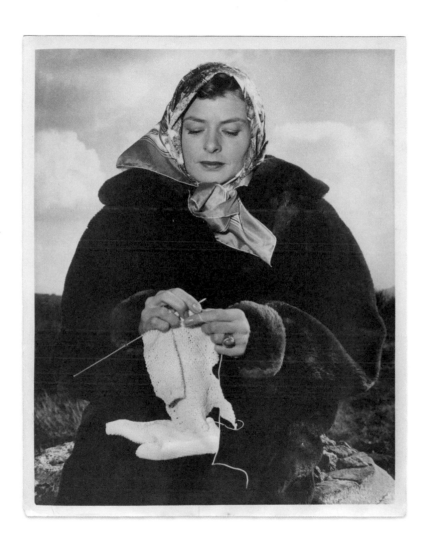

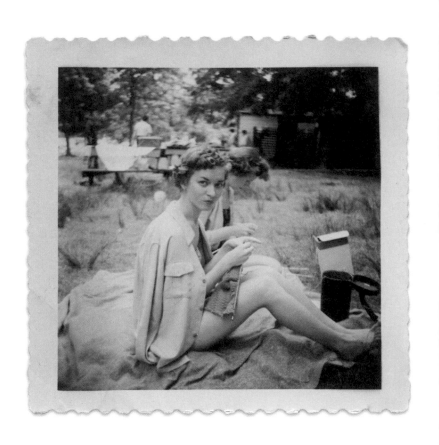

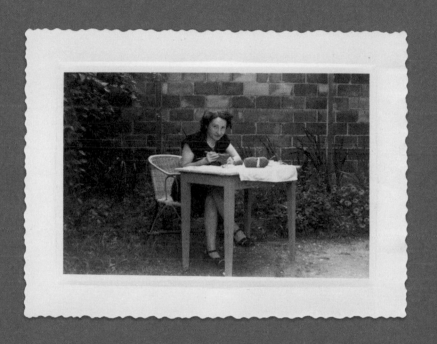

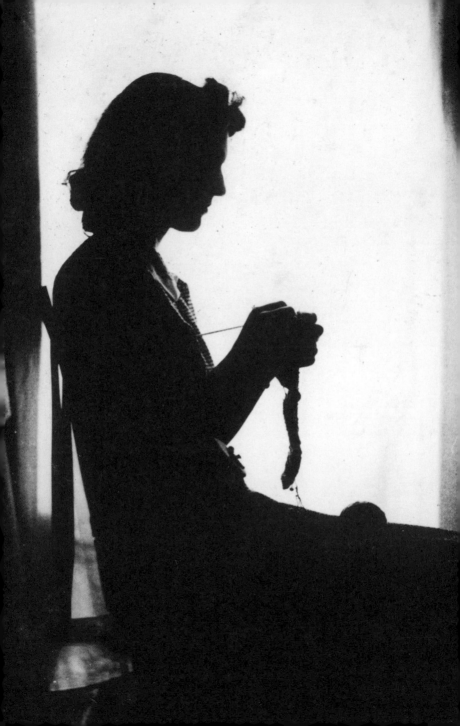

" Grand Duchess Marie pronounced knitting a wonderful escape from life's problems: 'When the needles slip through the fingers, your imagination takes flight.' "

—*NEW YORK TIMES*, MAY 12, 1936

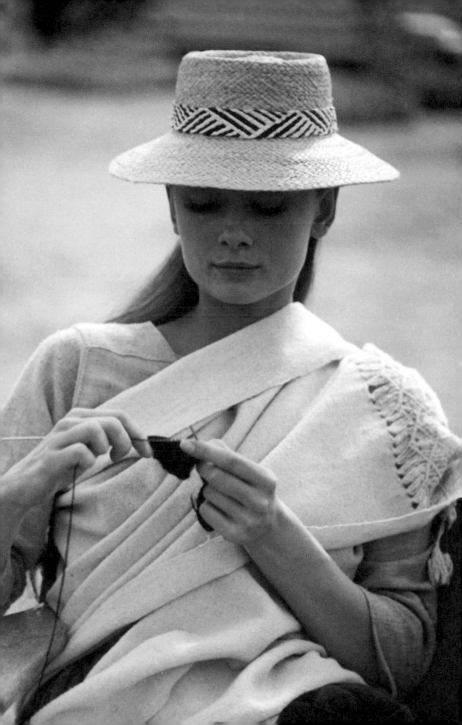

" *Vogue*'s merchandising manager asserted that fads had relatively little effect upon knitting yarn sales since hand-knit garments formed 'a basic part of the well-selected wardrobe.... Knitting appeals to a feminine instinct which many merchants overlook—the desire for individuality.' "

—*NEW YORK TIMES*, 1937

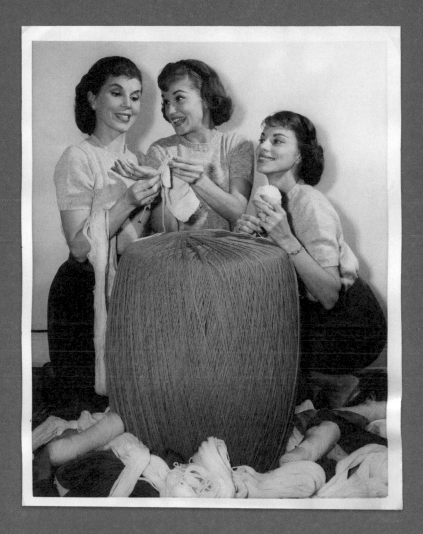

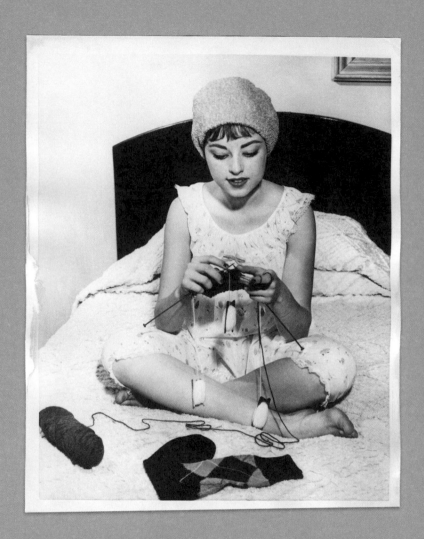

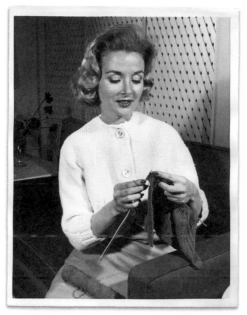

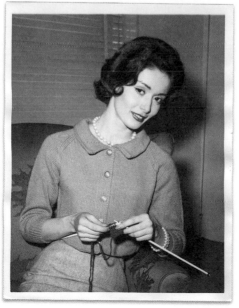

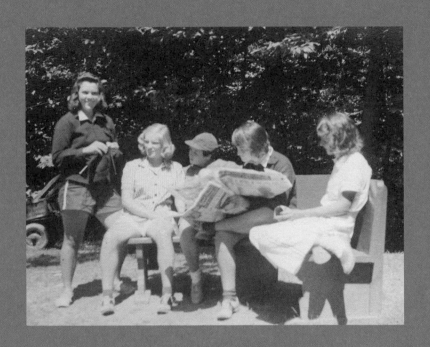

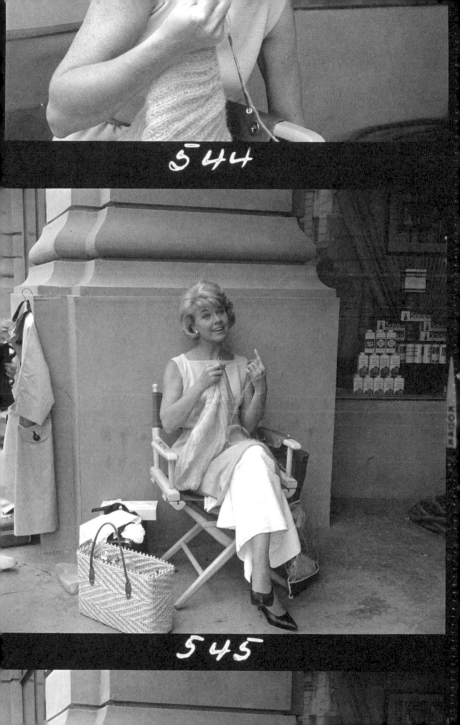

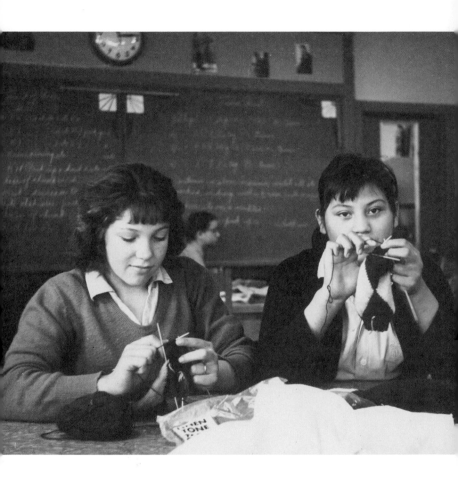

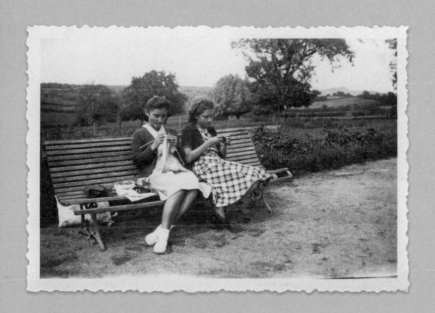

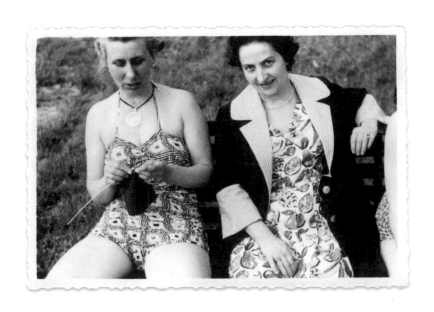

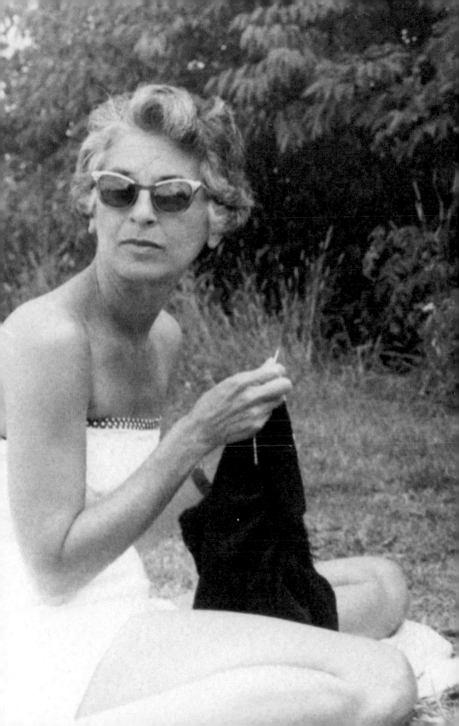

INDEX OF IMAGES

Unless noted, photographer is unknown and
photograph is in the collection of Barbara Levine.

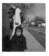
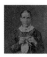
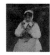
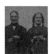
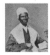

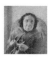

14: Photograph by James Callin, Staffordshire, United Kingdom, ca. 1880

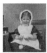

15: Commercial carte de visite by Poulton & Son, "The Cheerful Old Lady," ca. 1880. This charming staged scene plays on the stereotype of the little old lady knitting.

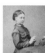

16: Photograph by J. Aitken, Hawick, Scotland, ca. 1900

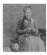

19: Cabinet card, studio of J. C. Munro, Aberdeen, Scotland, ca. 1900

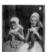

20: Postcard of Dutch girls knitting published by Utig F. B. den Boer, Middelburg, Holland, 1909

21: Cabinet card, ca. 1900

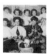

22: Real photo postcard of a Gibson girls' knitting circle, ca. 1910

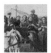

23: Graham's photo postcard series, "Scotch Fisher Girls," Blyth, England, ca. 1915. During fishing season fishing families would come from Scotland to England to catch herring. For the women, every spare moment was taken up with knitting.

24–25: Real photo postcard, ca. 1915

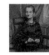

26: Studio portrait of young Scottish woman with her knitting, ca. 1915

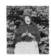

27: Studio portrait, ca. 1918

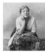

29: Halloween reveler costumed as a little old lady with her knitting, ca. 1915

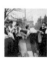

30–31: Photograph of women, most likely in a knitting circle, ca. 1914

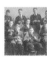

32: High school boys knitting for the soldiers during World War I, Cooperstown, New York, 1918

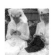

34: Red Cross nurses knitting, July 1918

35: Lithograph, American National Red Cross, ca. 1915. At the outbreak of World War I, the American Red Cross distributed this poster urging: "Knit Your Bit" to support the troops.
LIBRARY OF CONGRESS PRINTS AND PHOTOGRAPHS DIVISION

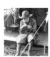

36–37: Knitting in National Military Service, ca. 1917. School for Women, Washington, DC

38–39: Postcard by Smith Bros., "Faithful Red Cross Worker," Dayton, Ohio, ca. 1918

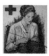

40: Color lithograph poster by Wladyslaw T. Benda, 1918
LIBRARY OF CONGRESS PRINTS AND PHOTOGRAPHS DIVISION

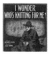

41: World War I–era sheet music, Winlee Music Co., New York, 1917

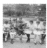

42–43: Bain News Service, "Knitting Bee," ca. 1918. Children knitting for the Red Cross
LIBRARY OF CONGRESS PRINTS AND PHOTOGRAPHS DIVISION

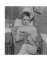

44: Vaudeville performer Frances White, ca. 1915
LIBRARY OF CONGRESS PRINTS AND PHOTOGRAPHS DIVISION

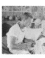

45: Bain News Service. On this negative is noted: "Interned German, Fort Douglas, knitting scarf," 1915
LIBRARY OF CONGRESS PRINTS AND PHOTOGRAPHS DIVISION

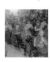

46: Prisoners knitting in one of their classrooms, Sing Sing prison, Ossining, New York, ca. 1915
LIBRARY OF CONGRESS PRINTS AND PHOTOGRAPHS DIVISION

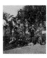

47: Men's knitting group, Florida, ca. 1918

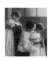

48: Real photo postcard, France, ca. 1918

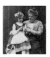

49: Real photo postcard, ca. 1918

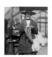

51: Seattle woman knitting while walking, ca. 1918

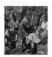

52–53: Real photo postcard, Clovelly, Devon, England, ca. 1920

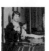

54: Snapshot, 1918

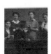

55: Knitting circle, ca. 1920

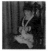

57: Catherine Smith, wife of New York governor Alfred E. Smith, 1924

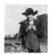

58: Snapshot of woman with knitting and knitting bag, ca. 1920

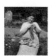

59: Snapshot, ca. 1920

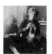

60: Spanish women knitting, winter 1922–23

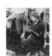

61: Mary Pickford knitting for the Red Cross, 1925
LIBRARY OF CONGRESS PRINTS AND PHOTOGRAPHS DIVISION

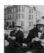

62: Snapshot, ca. 1920

63: Snapshot, ca. 1920

64–65: A woman fishing and knitting in White Plains, New York, 1939

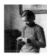

67: Snapshot, ca. 1935

68: Collaged photograph album page, ca. 1930

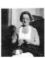

69: Hand-tinted snapshot, ca. 1920

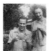

71: Snapshot, 1938

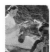
72–73: Photograph
by L. G. Scott, ca. 1930
SHETLAND MUSEUM
AND ARCHIVES

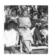
74: Photograph by Frank
Carpenter of five girls knitting
in Albania, 1925
LIBRARY OF CONGRESS
PRINTS AND PHOTOGRAPHS
DIVISION

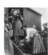
75: "Gutter girls" outside
a hut for seasonal workers
at a herring station, Lerwick,
Shetland Islands, Scotland,
ca. 1930.
The girls would knit while
not working with the fish.
SHETLAND MUSEUM
AND ARCHIVES

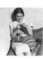
76: Photograph by J. Peterson
of a woman knitting a Fair Isle
sweater, ca. 1939–46.
Visible around her waist is
a knitting belt, a device used
to stabilize the needles, freeing
up the hands and preventing
them from tiring.
SHETLAND MUSEUM
AND ARCHIVES

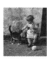
77: Photograph by J. Peterson,
ca. 1939
SHETLAND MUSEUM
AND ARCHIVES

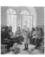
78–79: Women's Institute,
Jerusalem, Arab women
knitting in the Old City, ca. 1939
AMERICAN COLONY
(JERUSALEM) PHOTO DEPT.
LIBRARY OF CONGRESS PRINTS
AND PHOTOGRAPHS DIVISION

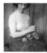
80: Photograph by J. Peterson of
a woman knitting a sweater with
A Fair Isle stripe, ca. 1939–46
SHETLAND MUSEUM
AND ARCHIVES

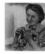
82: French photo montage
postcard, ca. 1940.
"Dream and reality /
Listen to my dearest desire:
On your breast to nestle!"

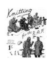
83: French poster, ca. 1940.
"The school, godmother
of the fighter / I, too, with
my classroom / have adopted
a soldier"

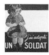
84: Vintage comic linen
postcard, ca. 1942

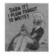
85: Royal Air Force Comforts
Committee, *Knitting for the
R.A.F*, London, ca. 1943

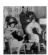

86–87: Knitting for the forces at the beauty salon, London, 1940.
On verso is written: "The English women, seen here knitting for the soldiers, do not waste time even while having their hair dried. The pieces of knitting on which they are working are provided by the beauty parlor and each customer is asked to do her bit for 'the boys.' She picks up where the previous person left off, and if it is a hard one to do she finds directions attached."

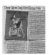

88: Sheet music for Glenn Miller's "Knit One, Purl Two" in a full page from a 1942 newspaper

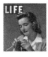

89: *Life* magazine, 1941. During World War II, knitting served as a way Americans could support the war effort. This issue of *Life* explained "How to Knit." Along with basic instructions, the article advised, "To the great American question 'What can I do to help the war effort?' the answer was 'Knit.'"

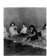

90: Red Cross Center, University of Hawaii, 1941. On verso is written: "Calmly knitting and comforting their children are these women evacuated from Pearl City after the bombing of Pearl Harbor by Japanese."

91: First Lady Eleanor Roosevelt knits while attending "We're in the Army Now," a conference held at Vassar College in Poughkeepsie, New York, 1941

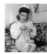

92: Joan Crawford in her trailer during filming of *When Ladies Meet*, 1941

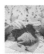

93: Photograph by John Vachon of a woman knitting, Washington, DC, 1941
LIBRARY OF CONGRESS PRINTS AND PHOTOGRAPHS DIVISION

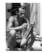

94: A German or Italian merchant seaman knitting a sleeve at the Immigration and Naturalization Service's detention station at Fort Lincoln, North Dakota, where sailors from impounded ships were interned early in World War II
FRANKLIN D. ROOSEVELT PRESIDENTIAL LIBRARY

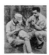

95: American soldier watches Chinese soldier knit, Kunving, China, 1945

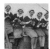

96–97: Nurses knit for soldiers, Melbourne, Australia, ca. 1940. Caption reads: "Socks? No, Scarves Maybe. A knitting bee waits for sailing time."
COURTESY OF ARGUS NEWSPAPER COLLECTION OF PHOTOGRAPHS, STATE LIBRARY OF VICTORIA

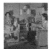

98: Mrs. S. Nako and Mrs. William Hosokawa spend an afternoon knitting at the Heart Mountain Relocation Center in Park County, Wyoming, January 8, 1943. They were among more than ten thousand Japanese Americans who were held at this internment camp during World War II.
COURTESY OF THE BANCROFT LIBRARY, UNIVERSITY OF CALIFORNIA, BERKELEY VOLUME 11, SECTION B, WRA NO. E-618

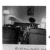

99: Snapshot, ca. 1945. Handwritten caption reads: "Knitting socks for Hubby"

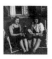

100: Snapshot, ca. 1940

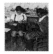

101: Girls engaged in knitting and making toy animals in the handicraft class of the St. Simon's Youth Center of the National Youth Administration, Philadelphia, Pennsylvania, 1941.
LIBRARY OF CONGRESS PRINTS AND PHOTOGRAPHS DIVISION

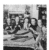

102–103: The Little Happy Gang children's knitting club, knitting for Canadian soldiers and for the Canadian Red Cross Society, Moose Jaw, Saskatchewan, Canada, May 1940.
VICTOR BULL, NATIONAL FILM BOARD OF CANADA, PHOTOTHÈQUE/LIBRARY AND ARCHIVES CANADA, ACCESSION NUMBER 1971-271 NPC, ITEM WRM 185, COPY NEGATIVE C-053880

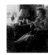

104: Snapshots, Lewiston, Maine, ca. 1940

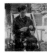

105: Snapshot, ca. 1940

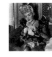

106: Betty Grable knitting baby clothes for her soon-to-be-born child with her second husband, bandleader Harry James, 1943

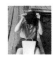

109: Snapshot, ca. 1940

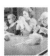

110: Photograph by Richard Boyer of women knitting at the Lighthouse, an institution for the blind in New York City, 1944
LIBRARY OF CONGRESS PRINTS AND PHOTOGRAPHS DIVISION

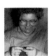

111: Snapshot, ca. 1945

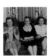

112: Snapshot, ca. 1950

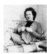

113: Snapshot, ca. 1945

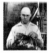

115: Maintenance man between furnace-checking chores knits for the baby his wife is expecting, 1951. On verso is noted that he "took up knitting five years ago for relaxation on advice of his doctor, and he's since become an expert."

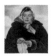

117: Ingrid Bergman knitting clothes for her twins (with husband, film director Roberto Rossellini), 1953

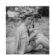

118: Snapshot, ca. 1950

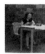

119: Snapshot, ca. 1950

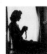

120: Snapshot, ca. 1950

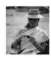

122–123: Audrey Hepburn on the set of *The Unforgiven*, 1959
MPTVIMAGES.COM

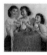

125: The singing trio the McGuire sisters were elected "Queens of Hand Knitting" in honor of Knit It Yourself With Wool Week in New York in 1958.

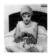

126: Woman knitting socks while drying her hair, 1960

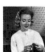

127: Woman knitting, ca. 1959

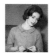 127: Woman knitting, ca. 1960

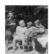 128: Snapshot, ca. 1960

 129: Doris Day knitting on the set of *A Touch of Mink*, 1962

 130: Lucy Benedict (left) and Dorothy Bush, students in the home economics class at the Central School on the St. Regis Mohawk Reservation, date unknown.
LIBRARY AND ARCHIVES CANADA, ACCESSION NUMBER 03675 (2000761273) 1976-281 NPC, MIKAN NUMBER 4046810

 131: Snapshot, ca. 1950

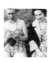 132: Snapshot, ca. 1960

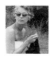 133: Snapshot, location identified as "Sokolows," July 1954.

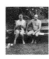 144: Photograph by Elliot Erwitt, Great Britain, 1968
MAGNUM PHOTOS

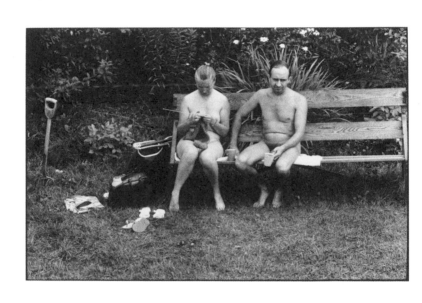

ACKNOWLEDGMENTS

Thanks to Peter Stein, for his love of words, storytelling,
and appreciation of histories both big and small. And to Paige Ramey,
for her invaluable research, keen eye, and unfettered enthusiasm.

PUBLISHED BY
Princeton Architectural Press
A McEvoy Group company
37 East Seventh Street
New York, New York 10003

Visit our website at www.papress.com.

EDITOR: Sara Stemen
DESIGNER: Mia Johnson

SPECIAL THANKS TO:
Janet Behning, Nicola Brower, Abby Bussel, Erin Cain, Tom Cho,
Barbara Darko, Benjamin English, Jenny Florence, Jan Cigliano Hartman,
Lia Hunt, Valerie Kamen, Simone Kaplan-Senchak, Stephanie Leke,
Diane Levinson, Jennifer Lippert, Sara McKay, Jaime Nelson Noven,
Rob Shaeffer, Paul Wagner, Joseph Weston, and Janet Wong
of Princeton Architectural Press —Kevin C. Lippert, publisher

Library of Congress Cataloging-in-Publication Data
is available on request from the publisher.

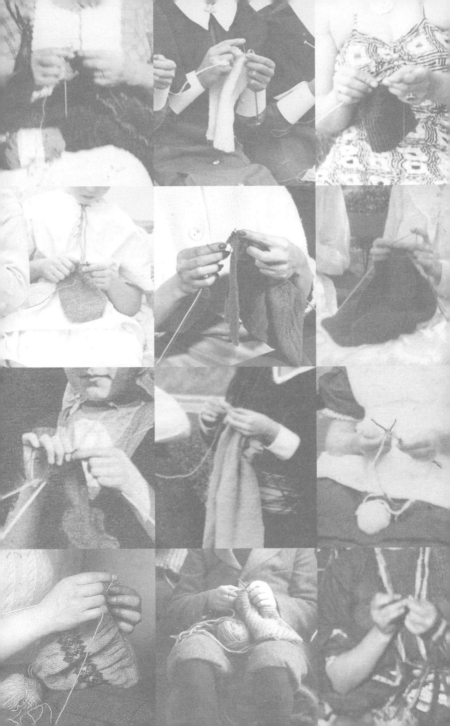

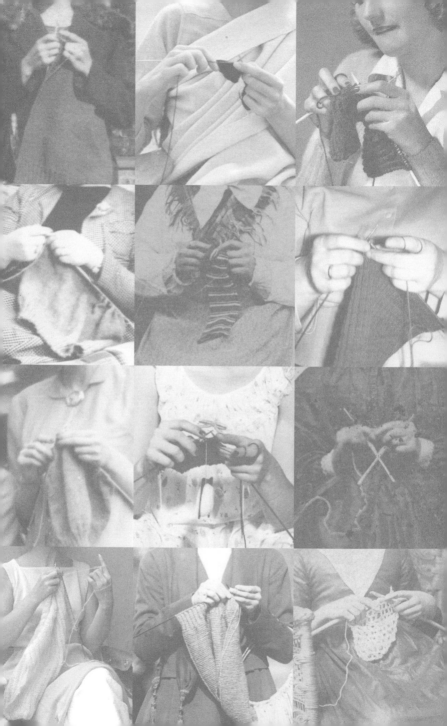